Penguins

101 Fun Facts & Amazing Pictures

(Featuring the World's Top 8 Penguins)

Table of Contents

Introduction

Penguins may share similarities with birds but they are flightless. Unlike other birds, penguins are aquatic. And they are indeed one unique member of the animal kingdom.

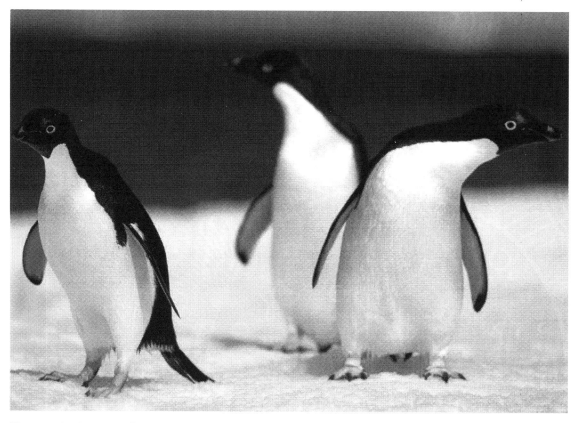

Figure 1: Among the cutest things about penguins are the way they seem to wear a tuxedo, the way they walk and the way they slide on their bellies playfully along the icy land.

1. Penguins are equipped with wing bones but these serve as flippers.

2. Their flipper-like wing bones may not be suited for flying but they are perfect for swimming.

3. The penguin's black-and-white appearance is used as a form of camouflage, keeping them safe from predators in the water.

4. Their diet usually consists of fish, krill and squid.

5. The penguin species that live close to the equator prefer fish diet while those close to Antarctica are more of krill and squid eaters.

6. Penguins spend more than half of their lives in the water.

7. They breed and raise their chicks on land.

8. They are usually found in the Southern Hemisphere and they do not live in the North Pole.

9. Penguins are extremely social. They do most of their activities in groups. They feed, hunt, breed, build their nests and raise their chicks together.

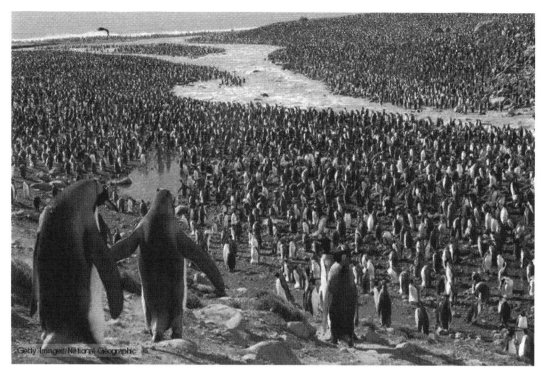

Figure 2: A visual proof of how social penguins are. They just like to gather around.

The Fierce Adelie Penguin

The Adelie Penguin is one of the most popular species. In fact, the appearance of Adelie is exactly what most people think about when they hear penguins.

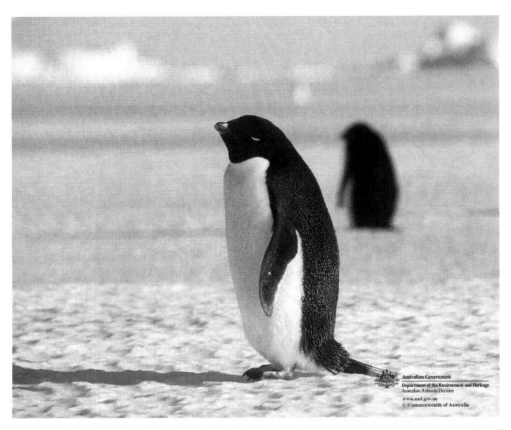

Figure 3: The Adelie Penguin looks like it is wearing a tuxedo, which is actually what a lot of people have in mind whenever they think of penguins.

10. The Adelie Penguin is quite short with a height not reaching more than 30 inches.

11. Despite its being short, it is quite heavy. In fact, these penguins are considered to be overweight for their height; they weigh approximately 8 to 13 pounds.

12. Although they are considered to be the smallest among Antarctic penguins, they prove to be capable of holding their own.

13. Among the most unique features of the Adelie penguin are the white rings around its eyes.

14. They may be short but they have longer tails compared to other penguins.

15. The Adelie's beak is red but its tip appears black.

16. These penguins are very social. They have a mellow nature and they get along just fine.

17. Another notable trait about these penguins is their powerful feet. This allows them to get around the ice with ease.

18. Do you wonder how the Adelie Penguins manage to leap from water to land without sliding or slipping? The incredible grip of their powerful feet allows them to survive and even appear to have fun in their harsh environment.

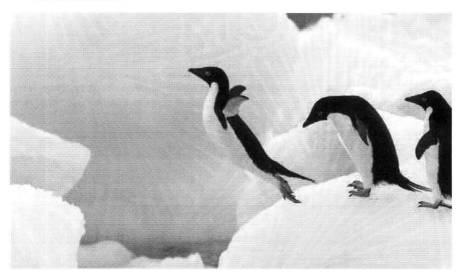

Figure 4: A group of Adelie Penguins lined up waiting for their turn to leap.

19. The Adelie penguins are said to be mellow by nature, and they also look like they are fun-loving. Watching these penguins slide on their bellies down the snowy hills would make you think that like really like to play. The truth is, these movements allow them get around the ice without tiring themselves out.

20. Their favorite food is krill but they also like squid, silverfish and crustaceans.

21. They are usually found in the Antarctic but during October or November, they move to the breed grounds. During this time, Adelie penguins show their fierce nature; they are likely to become aggressive when caring for their nests.

22. The Adelie Penguin would not hesitate to steal materials from its neighbor to build its own nest.

The Comical African Penguin

Penguins are usually associated with snow and ice, but make the African Penguin an exemption.

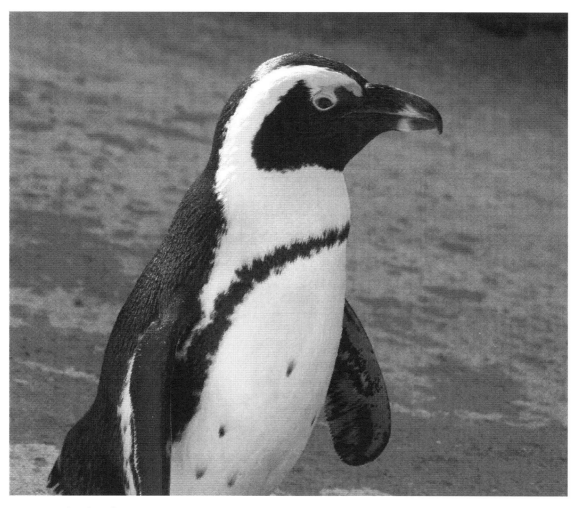

Figure 5: The distinct colors of the African Penguin allow it to easily blend with the color of its environment for protection against predators.

23. The African Penguin cannot be found in Antarctica or other snowy regions of the world. Rather, they live in the islands and coasts of South Africa.

24. The average height of an African Penguin is 2 feet. These penguins can weigh up to 8 pounds.

25. The male African Penguins are often a little bigger than their female counterparts.

26. These penguins have white feathers on their bellies and black feathers on their backs. Such features are meant for camouflage and protect them against their predators.

27. Freezing temperatures are not a problem for these penguins. In their habitat, they have to deal with high temperatures.

28. Because the African Penguin does not live on snow and ice, its feet are bare.

29. The lack of feathers in this penguin's feet helps with regulating excess heat in the body.

30. The African Penguins, however, still require protection against cold water. Their dense and water proof feathers allow them to remain dry and keep them insulated.

31. These penguins can dive into the water up to an average of 30 meters in depth. However, they are also quite capable of diving as deep as 130 meters.

32. They are excellent swimmers. Their average speed is at 7 kilometers (4.34 miles) per hour. But when hunting for food, they can swim as fast as 20 kilometers (12 miles) per hour.

33. Their favorite foods include sardines and anchovies. But they also eat crustaceans, squids and other kinds of fishes.

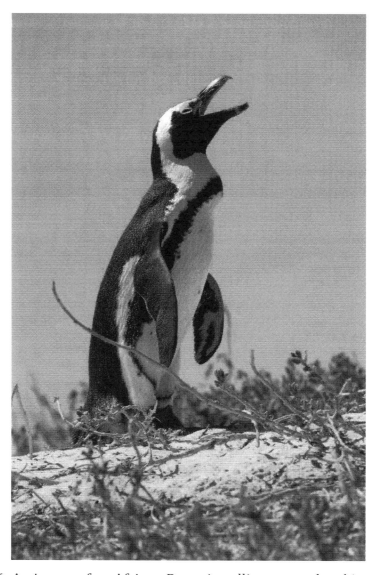

Figure 6: An image of an African Penguin calling out and making a sound similar to the braying of a donkey.

34. They are sometimes called "Jackass Penguins." That's because they can be rather loud; they sometimes sound like the braying of donkeys.

35. The average lifespan of African Penguins is 10 years.

The Awesome Emperor Penguin

The Emperor Penguin is awesome not just because of its size. This specie has many qualities that make it just as special as other penguins.

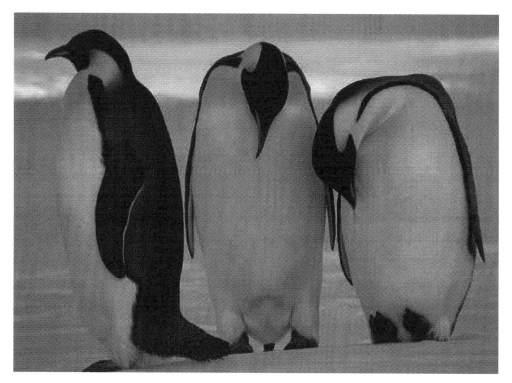

Figure 7: The Emperor Penguins are the biggest among the species.

36. The Emperor Penguins are the biggest out of the 17 known penguin species. They stand at an average height of 45 inches.

37. Unlike other penguins that move to other locations to avoid the harsh winter in the Antarctic, the Emperor Penguins stay put.

38. These penguins can tolerate low temperatures of up to -60 degrees Celsius (-76 degrees Fahrenheit). They are also quite capable of

withstanding blizzards with speeds of 200 kilometers (124 miles) per hour.

39. The Emperor Penguin's scale-like feathers are made of four layers. This gives them protection against the icy winds. Their feathers also serve as a waterproof coat when they hit the ice cold water.

40. Their bodies are also capable of storing enormous amounts of fat. It serves as insulation and provides a long lasting source of energy.

41. The Emperor Penguin can recycle its own body heat. That is because their veins and arteries are closer together.

42. They find it easy to move through the ice because of the powerful grip of their feet.

43. They also slide through ice on their sleek bellies so they can move along faster.

44. The Emperor Penguins are excellent swimmers. They can dive as deep as 1,850 feet and swim at a speed of 7.6 miles per hour.

45. They can stay under water for as long as or even more than 20 minutes.

46. After a male and a female Emperor Penguin mates and their egg is laid, the female penguin travels in the open sea to feed. Meanwhile, the male penguin is left behind to protect the egg until it has hatched.

47. When the egg is hatched, the mother Emperor Penguin comes back to take care of the baby penguin. This time, the father sets out to the open sea to find food.

48. Their favorite food includes krill, squid and other fishes.

49. The Emperor Penguin can live up to 20 years.

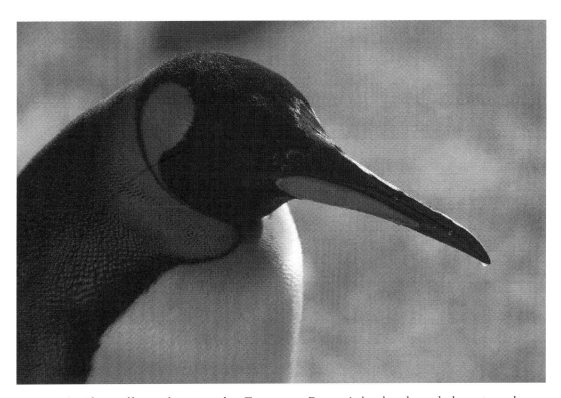

Figure 8: The yellow glow on the Emperor Penguin's cheek and throat make it look like it is blushing.

The Strange Galapagos Penguin

The Galapagos Penguins are probably the rarest among the penguin species. A strange fact about these penguins is that they are the only ones who have found a home north of the equator.

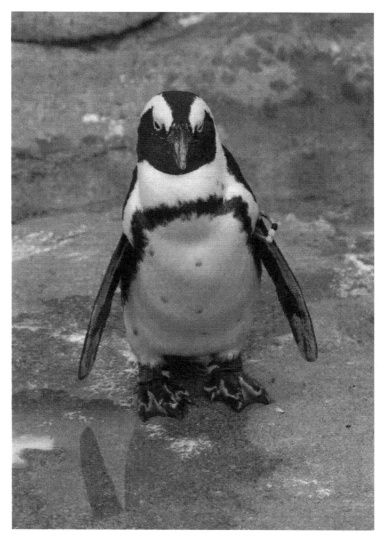

Figure 9: The Galapagos Penguin is the third smallest penguin species.

50. The Galapagos Penguins are rather small with a height of 19 inches and a weight of about 5 pounds.

51. The upper parts of their body such as the head are black while the lower parts are white. There appears to be black markings in their chest which look like an inverted horseshoe. There is a thin white line that outlines a curve from their eyes to their throat.

52. The Galapagos penguins are an endangered species with only about 1,000 breeding pairs left in the world.

53. These penguins are sociable. In fact, they would not act aggressively when people approach them so long as humans keep a distance of 3 meters (approximately 3 yards and 1 foot).

54. The adult and young Galapagos Penguins like to eat sardines, mullet and crustaceans.

55. The Galapagos is not very fond of exposing itself to the sun's rays. The adult Galapagos penguins also ensure that their eggs are hidden from sunlight so they put the eggs under the steep rocks.

56. These penguins would stay near the water during the day time. But when the night comes, they would stay on land. This behavior is due to the fact that they are dealing with extreme cold weather in their habitat.

57. Although some penguins stick to one partner for just one breeding season, the Galapagos penguin would stick to one partner for their entire lifetime.

58. The father and mother Galapagos Penguins take turns in taking care of their babies especially during the incubation process which takes about 30 days.

59. Sixty to sixty-five days after the chicks come out of their shells, they are already quite capable of taking care of themselves.

60. Because they are relatively small, these penguins are hunted by snakes, owls and hawks. Seals, sea lions and sharks also feed on these penguins.

61. If the Galapagos Penguins survive from predators, they can live for 15 to 20 years.

The Regal King Penguin

King Penguins are indeed regal. They appear to carry themselves with dignity based on the way they stand up so straight.

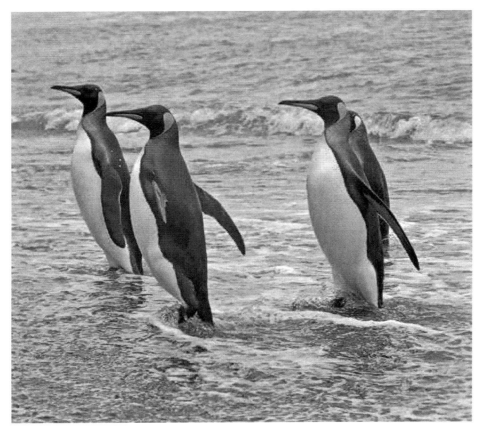

Figure 10: The King Penguin looks similar to Emperor Penguins because of their upright posture, sleek coat and the glow on their necks and cheeks.

62. These penguins are the second largest penguin species next to the Emperor Penguin.

63. The King Penguin stands 3 feet tall and weighs an average of 35 pounds.

64. They have orange spots on their necks and near their ears.

65. King Penguins have flat flappers, stiff wings and webbed feet. All these features allow them to easily propel through water.

66. While most penguin species are almost entirely black in appearance, the King Penguins are somewhat special with their blackish brown head, dark golden ear markings and a silvery grey back.

67. They live in a warmer habitat around the more temperate islands of northern Antarctica. But just the same, they have four layers of feather, similar to what Emperor Penguins have.

68. They also huddle together to keep each other warm.

69. These penguins like to eat fish. But they also feed on crustaceans and squid.

70. A female King Penguin is only capable of laying and hatching one chick at a time.

71. A King Penguin chick looks very different from an adult. It will have fuzzy brown feathers, and it will look like that for about a year after its birth.

72. The King Penguin's age of maturity is three years. Most of them will not start breeding until they are six years old.

The Beautiful Little Blue Penguin

Despite its size, the Little Blue Penguin is undeniably beautiful.

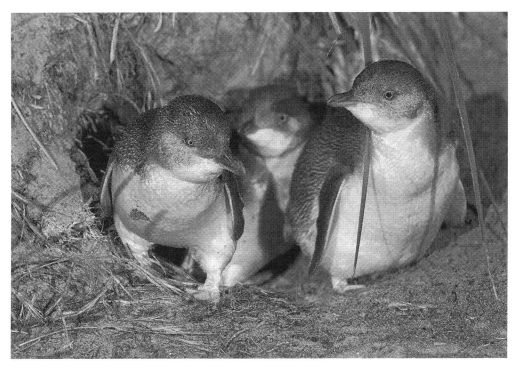

Figure 11: Little Blue Penguin families would leave their nest together for food hunting in the ocean.

73. They are the smallest among all penguin species with a height of only 13 inches and a weight of only around 2 pounds.

74. They live along the New Zealand coast and the southern coast of Australia. They are also usually found in the surrounding islands.

75. Unlike other penguins with the usual black coating, the little blue penguins have steel blue coats with white bellies.

76. The Little Blue Penguins may be small but they can swim at a speed of 6 kilometers (3.72 miles) per hour.

77. They spend most of their days in the ocean where they get their food.

78. They like to eat squid, fish and crustaceans.

79. They only come back on land after dark so they could avoid being spotted by humans.

80. Little Blue Penguins are monogamous. They would choose one mate and stick with their partner for life.

81. A breeding pair of Little Blue Penguins will usually lay 1 to two eggs at a time.

82. A Little Blue Penguin chick becomes independent after eight weeks of being hatched.

83. Little Blue Penguins shed and grow a new coat every year between the months of November and March.

84. Because of their small size, these penguins are hunted by cats, dogs, rats, weasels, stoats and ferrets.

85. The Little Blue Penguin's average life span is 6 to 7 years. But they tend to live longer in captivity with a lifespan of up to 20 years.

The Burrowing Magellanic Penguin

This penguin species is native to Brazil and South America. The Magellanic penguin is considered medium-sized. One of the unique facts about this penguin is that they burrow for their nests.

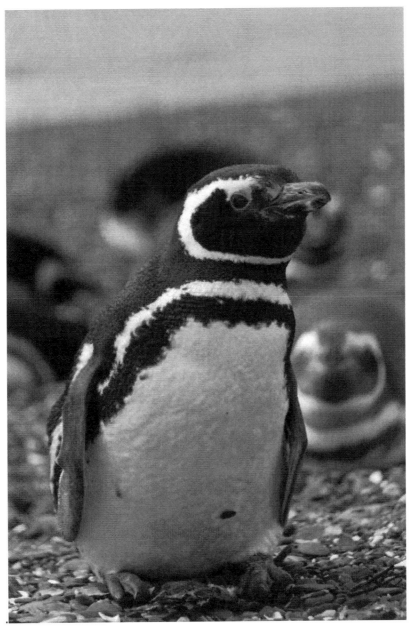

Figure 12: The Magellanic Penguin has a black and white coating with a white thin line around its face and a horseshoe shaped band in its front.

86. The Magellanic Penguin stands at 24 to 30 inches in height and weighs 5.9 to 14.3 pounds.

87. They like to feed on sardines, krill, squid, crustaceans and cuttlefish.

88. These penguins like to attend large gatherings.

89. They can be found in the coast of Argentina, Southern Chile and Falkland Islands.

90. They have their nests built on tree cavities and burrows.

91. The female Magellanic Penguin usually lays two or three eggs at a time which need to be incubated for 39 to 42 days.

92. Upon hatching, the chick stays with its parents for 30 days.

93. These penguins can live for about 25 years out in the wild and around 30 years in captivity.

The Bad-tempered Rockhopper Penguin

The Rockhopper Penguin may not exactly be bad tempered, but its looks give such an impression.

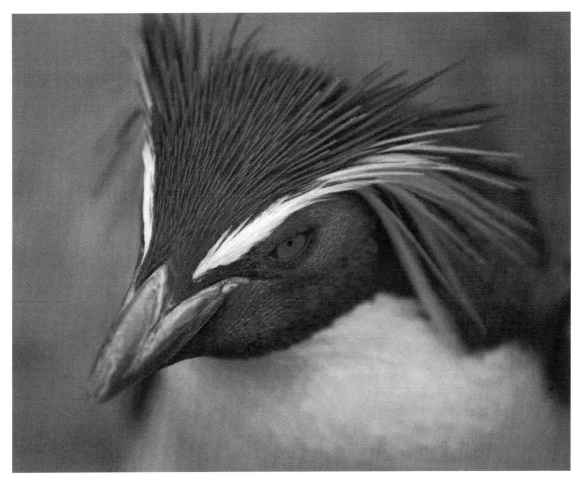

Figure 13: Among the most unique features of the Rockhopper Penguin are its yellow feather plumes and red eyes that make it look pissed all the time.

94. The Rockhopper Penguin is among the smaller penguin species.

95. They are usually found in the surrounding islands of the Indian and Atlantic Oceans including the Antarctic Polar Front.

96. Their average height is only only 52 long (20.5 inches) and they weigh between 2.3 and 2.7 kilograms (5 to 6 lbs.).

97. They can dive as deep as 100 meters (109 yards).

98. The Rockhopper Penguin is considered the most aggressive among the penguin species.

99. For food, they like krill, fish, squid, myctophid and euphasid fish.

100. They usually leave the islands for breeding.

101. They can live as long as 10 to 20 years.

Conclusion

As humans, we are fascinated by the way the animal kingdom works. This book has allowed you to take a glimpse of the 8 out of 17 fascinating penguin species.

Penguins may share similar characteristics. But each species is unique. And like people, these flightless birds are social. They depend on each other.

Thank you for downloading this book and I hope you enjoyed it!

61649463R00018

Made in the USA
Middletown, DE
12 January 2018